THE TOPOGRAPHY OF TEARS

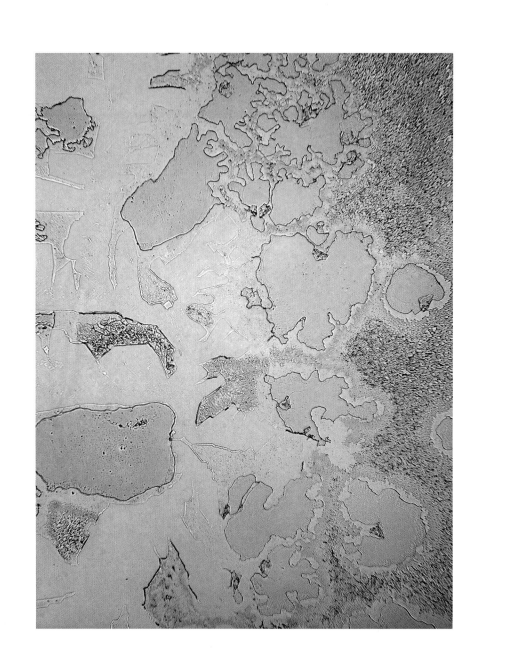

THE TOPOGRAPHY OF TEARS

Rose-Lynn Fisher

Bellevue Literary Press
NEW YORK

Caption for frontispiece illustration on page 2:
Thankful for exactly this

First published in the United States in 2017 by
Bellevue Literary Press, New York

For information, contact:
Bellevue Literary Press
NYU School of Medicine
550 First Avenue
OBV A612
New York, NY 10016

Library of Congress Cataloging-in-Publication Data
is available from the publisher upon request

Bellevue Literary Press would like to thank all its generous donors
—individuals and foundations—for their support.

 This publication is made possible by the New York State Council on the Arts with the support of Governor Andrew Cuomo and the New York State Legislature.

 This project is supported in part by an award from the National Endowment for the Arts.

Book design and composition by Mulberry Tree Press, Inc.
Manufactured in China.
First Edition
1 3 5 7 9 8 6 4 2
paperback ISBN: 978-1-942658-28-3

ebook ISBN: 978-1-942658-29-0

To my mother,
loving and courageous
always

Tear: [Latin. lacrima, lacruma, for older dacruma] [Greek. dakry, dakryon, dakryma] A drop of the limpid saline fluid secreted, normally in small amounts by the lachrymal gland, and diffused between the eye and the eyelids to moisten the parts and facilitate their motion. Ordinarily the secretion passes through the nasolacrimal duct into the nose, but when profuse it overflows the lids.

It is such a secret place, the land of tears.

Antoine de Saint-Exupéry
The Little Prince

INTRODUCTION

Rose-Lynn Fisher

The Topography of Tears is a study of tears photographed through an optical microscope. I embarked on this project in 2008, during a pivotal period of loss, sorrow, and change. On a day of endless tears, I suddenly wondered, what are tears? What do tears really look like? Are tears of grief different than tears of happiness? As a child I had seen an exhibition that showed microscopic views of all the things teeming in a single drop of pond water. Now I wondered what might be seen in a single tear.

So began this series of photomicrographs that includes a wide range of my own and others' tears, from tears of elation to tears of remorse, tears of laughter to tears of reverence, tears of grief and gratitude, birth and rebirth, chopping onions, and many more, each a tiny history.

The random compositions I find in magnified tears often evoke a sense of place, like aerial views of emotional terrain. Though the empirical nature of tears is a composition of water, proteins, minerals, hormones, and enzymes, the topography of tears is a momentary landscape, transient as the fingerprint of someone in a dream. The accumulation of these images is like an ephemeral atlas.

Roaming microscopic vistas, I am struck by the visual similarities between the vast and tiny worlds within worlds of life all around us, and inside of us. The patterning of nature seems so consistent, regardless of scale. Patterns of erosion etched into earth over millions of years can resemble the branched or crystalline forms in an evaporated tear that took less than a minute to occur.

Tears are the medium of our most primal language in moments as unrelenting as death, as basic as hunger, and as complex as a rite of passage. They are the evidence of our inner

life overflowing its boundaries, spilling over into consciousness. Tears spontaneously release us to the possibility of realignment, reunion, catharsis, intractable resistance short-circuited. Shedding tears, shedding old skin. It's as though each one of our tears carries a microcosm of the collective human experience, like one drop of an ocean.

Process and context

Tears are saved on a glass slide and left to air dry, or are compressed between a glass slide and a cover slip. Viewing at a magnification of 100x through an optical microscope, I wander in search of a "region of interest" and then photograph it with a specialized microscopy camera.

This is not a controlled scientific study, so there are many variables influencing the resulting image: the volume of tear fluid, evaporation or flow, biological variations, microscope and camera settings, and how I process and print the photograph. Among the same tears saved in the same moment, the resulting images may look quite different from one another. Even within one tear drop there is variation from one tiny region to another. While I've looked at the tears of men, women, and children of different ages, most of the tears in this study are my own.

I am continually surprised by what shows up in the photographs of microscopic tears, and what these images elicit in me. Some images evoke the emotion of the tear that produced them. Others somehow awaken an insight about the significance of a moment, a flash of knowing at the edge of articulated thought. Still others seem to show me where I've been, and I contemplate the visibility of a placeless place that can neither be fully explained nor revisited.

What accounts for all the differences we can see in these tears? My early questions remain unanswered among others yet to be asked. For me, it's the question that launches the journey and what I find along the way. Instead of conclusions, my exploration of tears has led me deeper into the intangible poetry of life. It seems I've come full circle: the more tears I look at, the more I marvel at what they present on their own terms, and I abide in the unknowable.

FOREWORD

William H. Frey II, PhD

Crying: The Mystery of Tears by Frey and Langseth (1985) and the scientific articles that preceded it in the early 1980s, brought new attention to the question of why humans evolved the ability to cry emotional tears in response to stress, why and how women and men cry differently, and how emotional tears differ from other kinds of tears. My hypothesis that emotional crying evolved as a means to alleviate emotional stress and that we may feel better after crying by removing, in our emotional tears, chemicals that build up during stress, i.e. by "crying it out," was intriguing to many. The media attention to emotional crying and the mystery of human emotional tears that was peaked at that time has continued to this very day. Of course, ideas about why we cry are nothing new as witnessed by the writings of Ovid, Darwin, Montagu and others.

Over the years, we learned from our work that women cry about four times as often as men and that emotional tears are chemically different from tears shed in response to eye irritation, suggesting that something unique is happening when we cry emotional tears. We have also learned from the work of Ann Cornell-Bell that the tear glands of men and women are anatomically different and from earlier work in mice by Martinazzi and Baroni that the hormone prolactin, which is elevated in women, likely contributes to this gender difference in the anatomical development of the tear glands. Thus, while societal conditioning is important, biological differences in the tear glands of men and women likely contribute greatly to why women cry more easily and more often than men.

The importance of the unique evolution in humans of the ability to cry tears in response to stress has been highlighted by the many studies indicating the damaging effects of

unalleviated stress on both the brain and the heart. Chronic unalleviated stress leads to elevations in cortisol, a stress hormone. Sapolsky and others have shown that cortisol can block the uptake of blood sugar (glucose) into brain cells resulting in starvation of these cells and eventually even the death of cells in key areas of the brain. Degeneration and loss of cells in those same areas of the brain are also known to occur in Alzheimer's disease and have been associated with decreases in glucose metabolism and brain cell energy. In fact, my discovery of the intranasal insulin treatment for Alzheimer's disease and certain other brain disorders is an approach to increase the uptake and utilization of glucose by the brain to prevent this kind of brain degeneration. This intranasal insulin treatment has been shown in human clinical trials to improve memory and functioning in patients with Alzheimer's disease and even to improve memory in normal-functioning human adults.

Rose-Lynn Fisher has taken an artistic approach to the investigation of the human physiological response to emotion by visually examining human emotional tears under the microscope. Her stunning photographs transport us to a previously unseen world in which we undertake the exciting visual exploration of the shapes, textures, and topography of human emotional tears. The abstract nature of this art is challenged by the obvious patterns of nature that infuse it and remind us of the intrinsic intelligence present in the world around us. It is important to view these evocative images for what they are, both art and a journey into an unseen world, and not to approach them in search of answers to specific questions that they are not intended or designed to provide. Best appreciated for the wonder and emotion they evoke, Rose-Lynn's photographs also invoke within us a new set of emotions as individual as each of its viewers.

What a pleasure it is to see how the continuing mystery of tears and crying has led to this photographic exploration of emotional tears, a uniquely human response to emotional stress.

—William H. Frey II, PhD
Founder and Senior Research Director
HealthPartners Neurosciences
St. Paul, Minnesota

ON TEARS

Ann Lauterbach

Tear. It's a neat little word, a single syllable, with "ear" tucked within, mingling two senses, seeing and hearing. We weep and all five senses collapse into a singularity: taste of salt, wetness of skin, sight blurred, ears filled with the rush of a pulsing, breaking breath, the thick scent of gladness or sorrow. The fluid that falls from the eye, the tear drops, and the rip or tear in fabric—originally of skin or leather—are not from the same etymological root but their meanings are aligned through analogy: the tear and the tear, one rhyming with here, the other with there, bound by a kind of materialism in which *force* plays its hand. Tear gas arrives in 1917. To be torn between two things is from 1871. To shed tears is from the 15th century, and to fill with tears is from the middle 17th century.

 "For a tear is an intellectual thing" the great subversive 19th-century poet William Blake wrote, railing against the Deists, classical and contemporary; he believed they had stripped religion of its signal call for forgiveness, assigning too much authority to a single God and making human life untenable in its guilty abrasions. Tears are *intellectual* because they come from thoughts that spill over the body's containing well; they are the secretion of excess we assign to emotion; perhaps emotion itself is simply caused by a surfeit of thought. One tries to unbind these durable dualities, to allow for the morphological shift that might allow the human creature to be complex but integrated, not divided into anatomical parts, all nouns and no transitive verb. We are not yet mechanical, technological things, we are intellectual—thinking—beings, and we cry when stirred beyond the capture of signifying Logos, which relents into flows of passionate silence. Perhaps this flow is the very proof that we cannot put our feelings in one place and our thoughts in another, the bleak result of a certain rationalism

that threatens to overtake our civility—our capacity to forgive—and wants to make all our ideas into abstractions, rigid and blunt, free of secretions.

Cry cry cry, Janis Joplin sang, stretching the syllable into a protracted wail, as if to break glasses, spilling their contents into the cupped hands of a generation seeking radical changes in the conception of human happiness. *Cry me a river*, sang Ella Fitzgerald, Julie London, and Justin Timberlake, *I cried a river over you*. Love's labors lost. We weep for our losses, we weep for our dead, who leave behind merely a name: Joe, Jennifer, Leslie, Peter, Priscilla, Bill. We erect monumental walls inscribed with the names of fallen soldiers and innocent victims; we engrave the stones.

And then there are the tears of victory: the athlete's triumph, the great person elected, the little girl escaped from harm's way, the boy saved from drowning by a stranger, the lovers reunited. We weep for the passage of a bill that changes how a culture thinks about its citizens. And we weep for beauty, perhaps the most perplexing of our reasons for tears, aroused by something that has allowed the perplexities and turbulence of a perilous life to be distilled into form: the mosaics in the Blue Mosque in Istanbul, a fresco depicting the death of Saint Francis by Giotto, a saxophone solo by John Coltrane, a play by Samuel Beckett, a novel by Toni Morrison, a film, say *The Great Beauty* directed by Paolo Sorrentino; the *Lachrimosa* movement in Mozart's Requiem Mass. *Lachrimosa* means weeping in Latin.

"All things swim and glitter," Ralph Waldo Emerson wrote at the beginning of his essay *Experience*, detailing his journey through the grief for his young son Waldo's death. Through tears, the whole world and its objects become fluid: "I take this evanescence and lubricity of all objects, which lets them slip through our fingers when we clutch hardest, to be the most unhandsome part of our condition."

A tear is an intellectual thing.

—Ann Lauterbach
August 2016

THE TOPOGRAPHY OF TEARS

Watery eyes: a micro climate

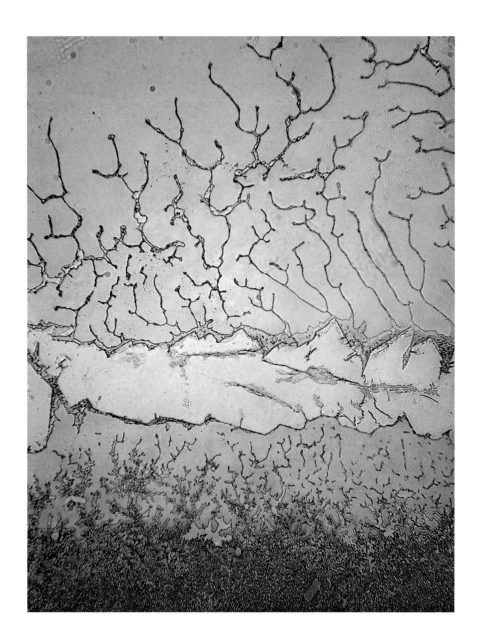

Tears of timeless reunion (in an expanding field)

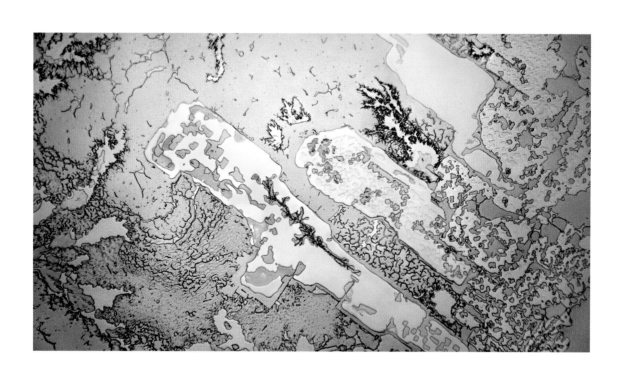

Tears of change

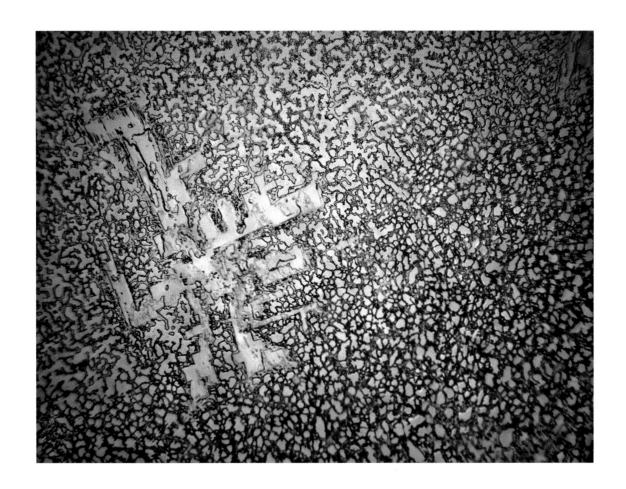

Momentum, redirected

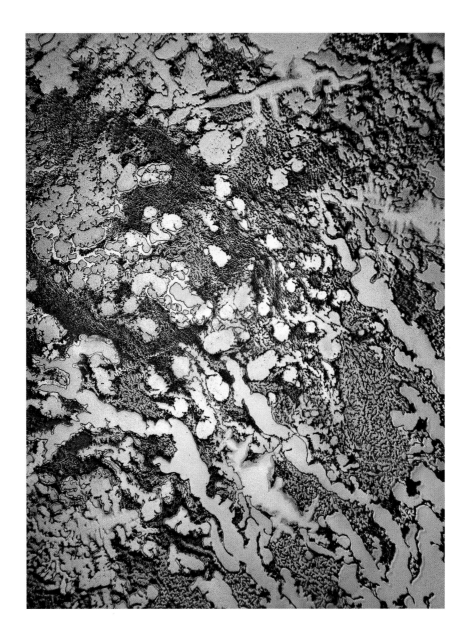

Ending and beginning

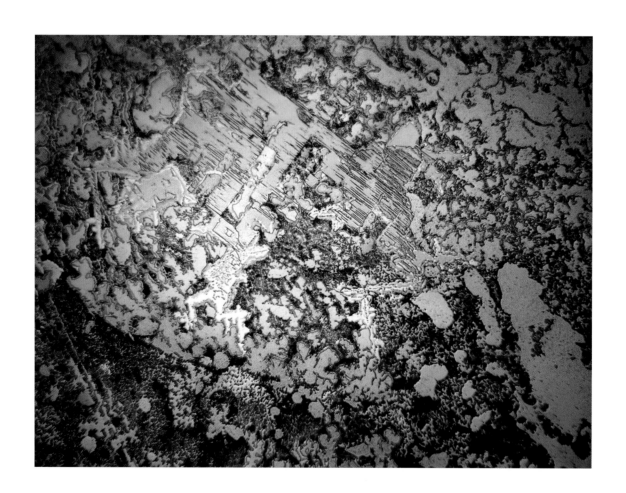

Tears of elation at a liminal moment

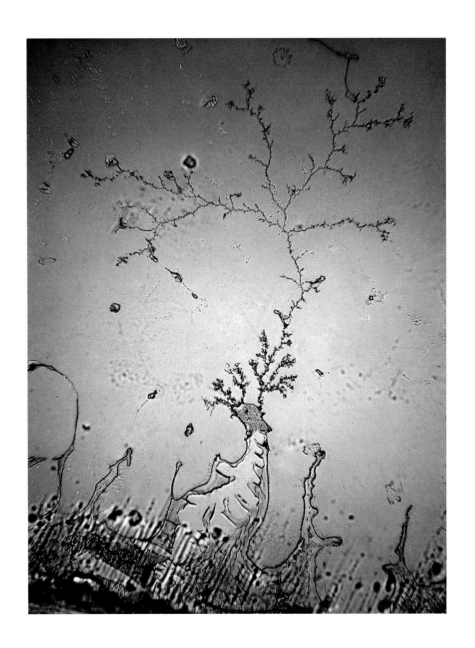

Laughing till I'm crying

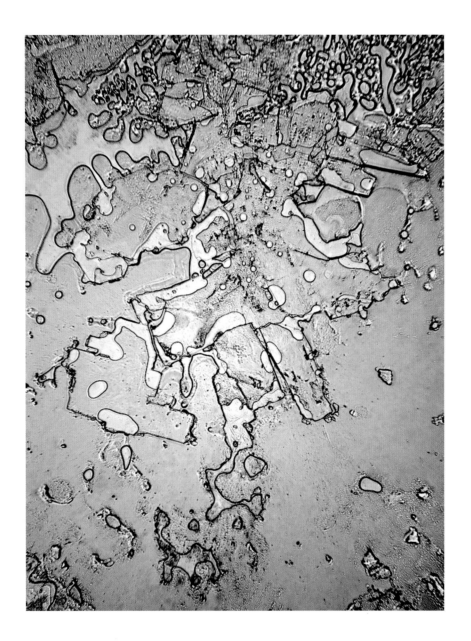

What couldn't be fixed

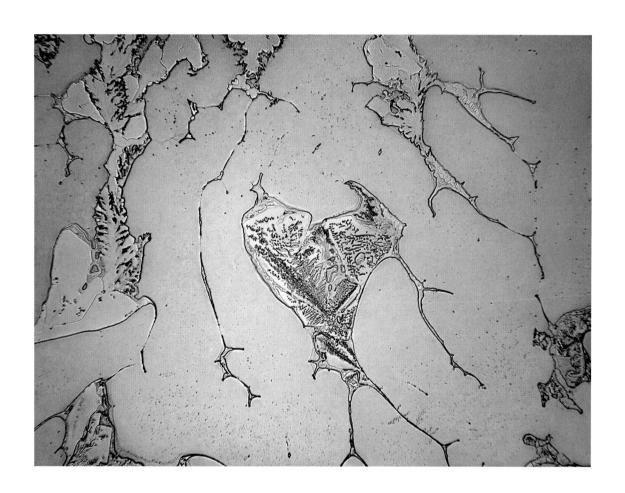

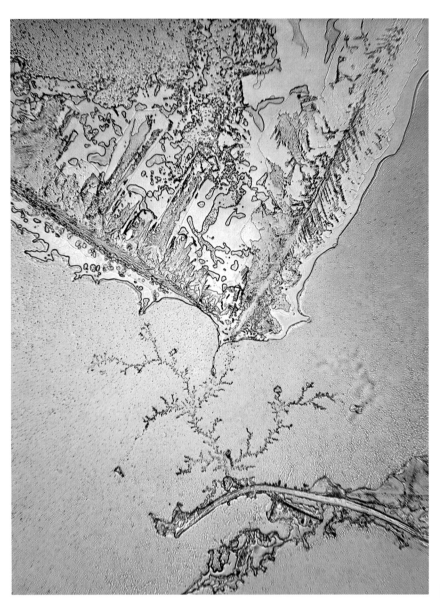

Resolution

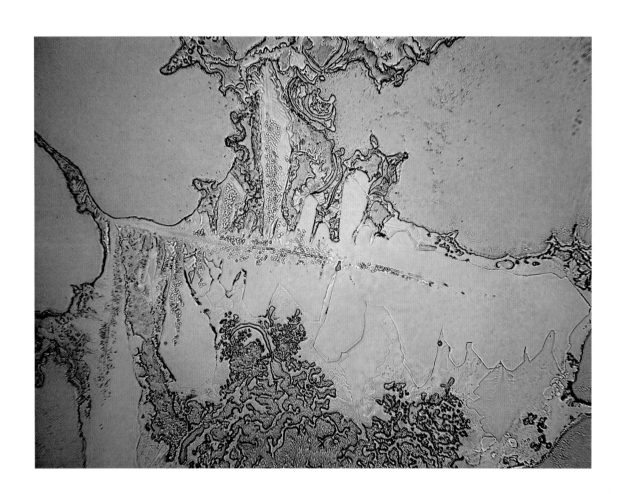

Full measure

Go!

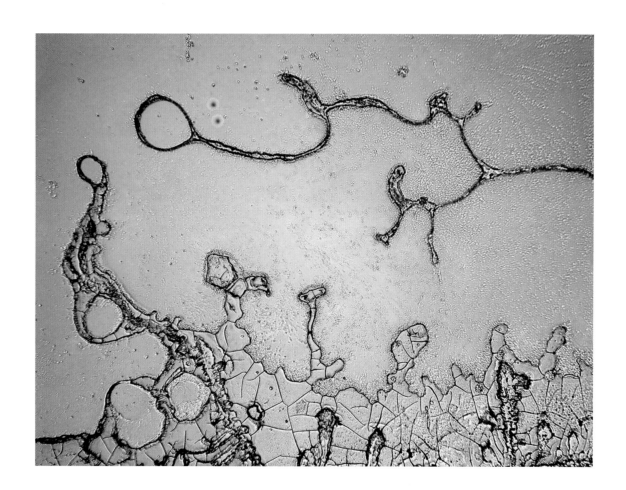

Remorse

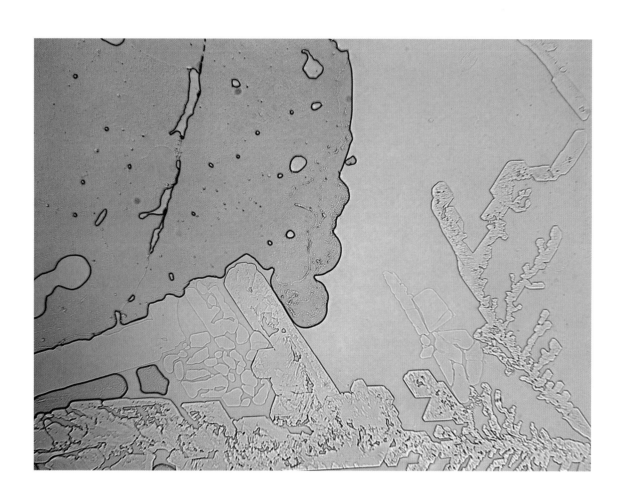

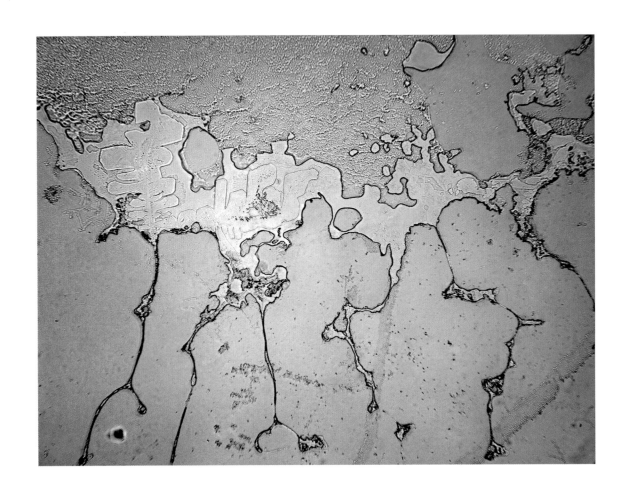

Aberration

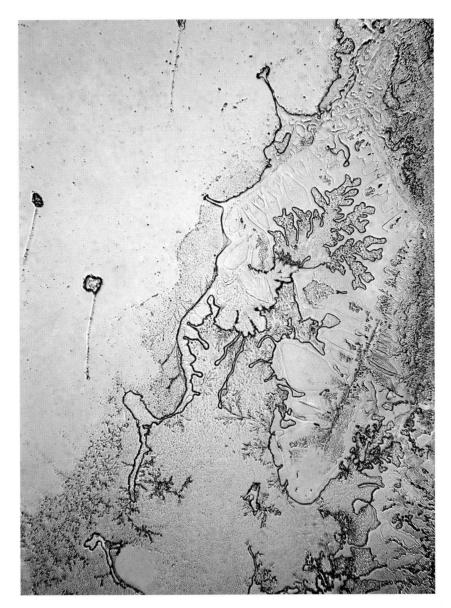

The brevity of time (out of order) losing you

As she crossed over the bridge disappeared

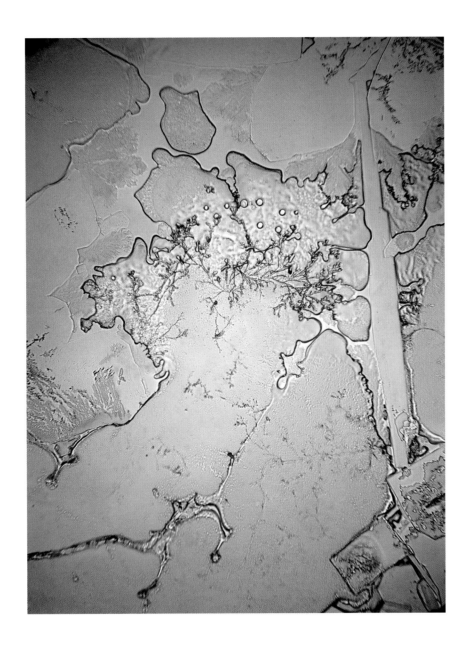

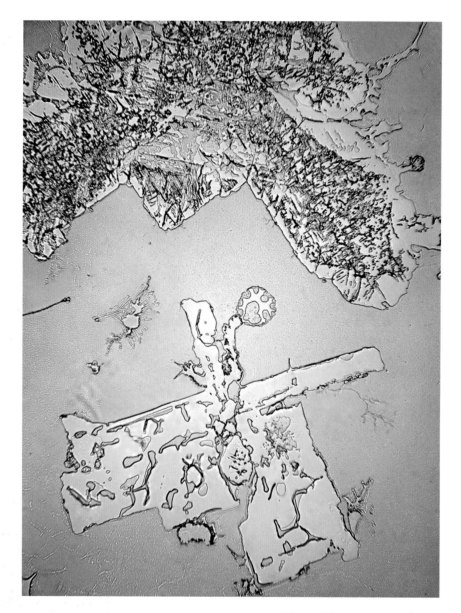

The pull between attachment and release

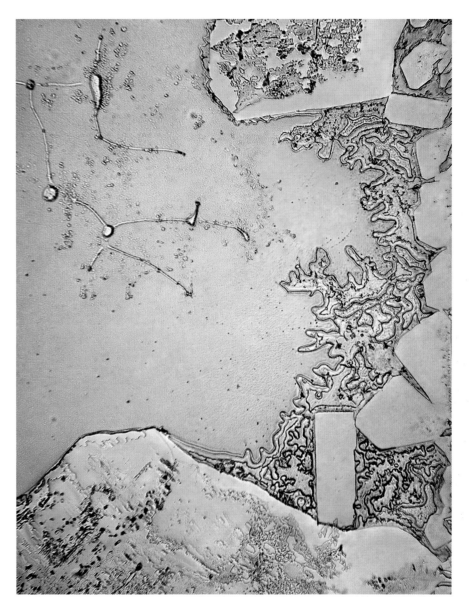

The irrefutable

Mom happy tears

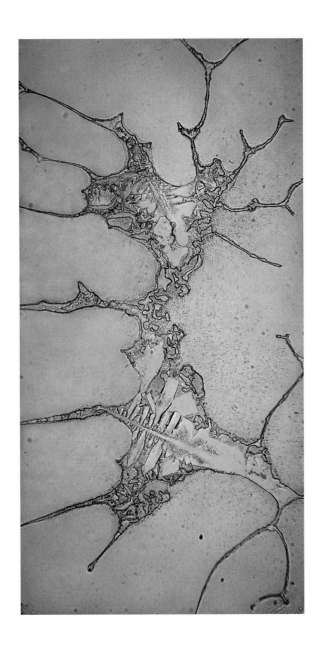

Possibility / hope

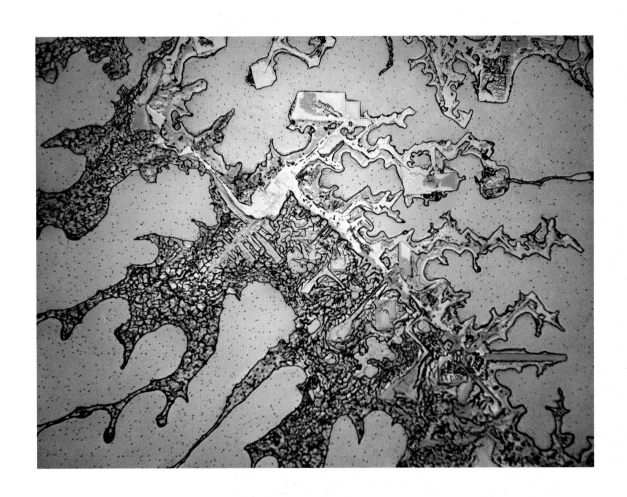

Tears of grief

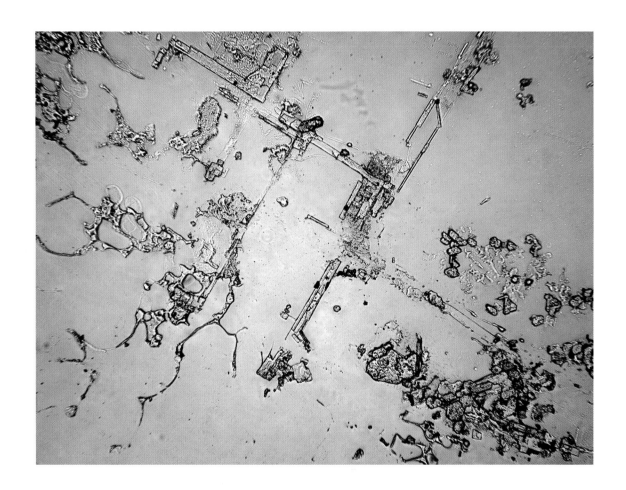

Grief and gratitude

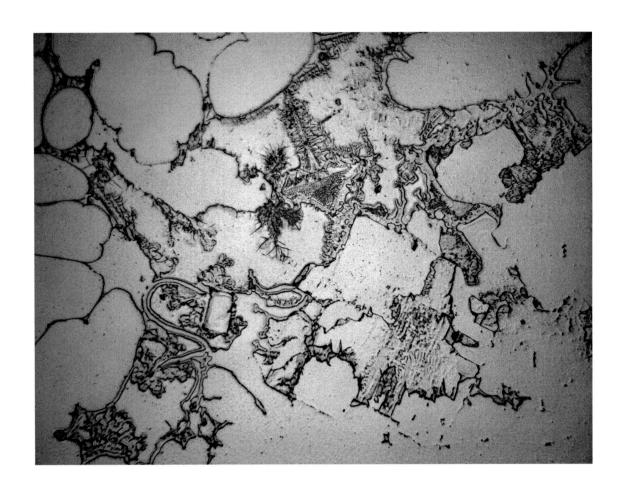

Your misery

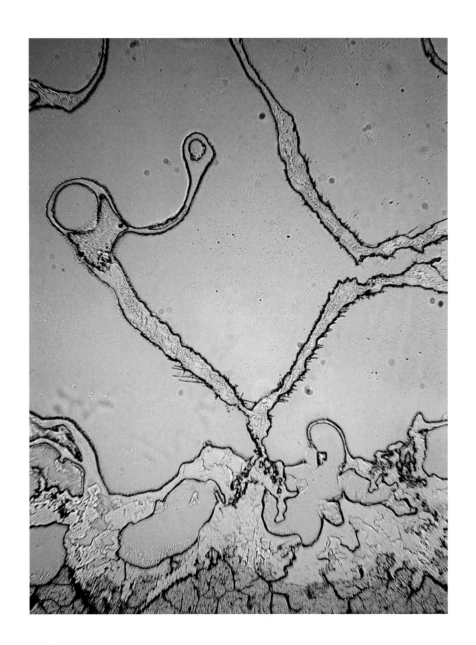

Catharsis

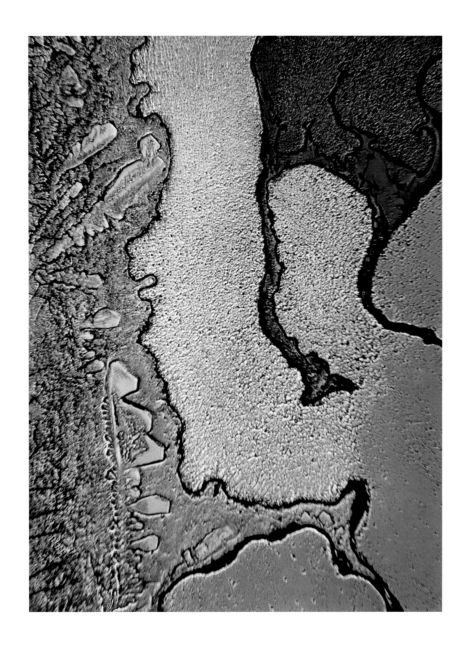

Yes

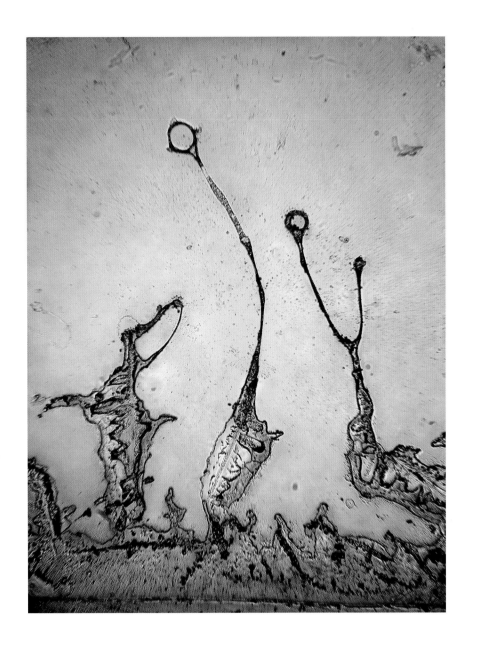

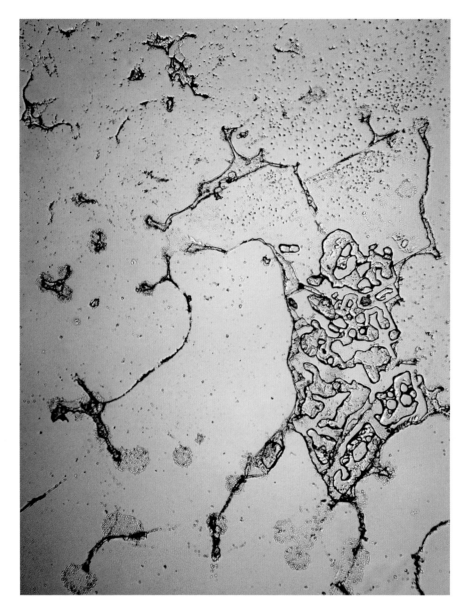

A swarm of emotions heading out to parts unknown

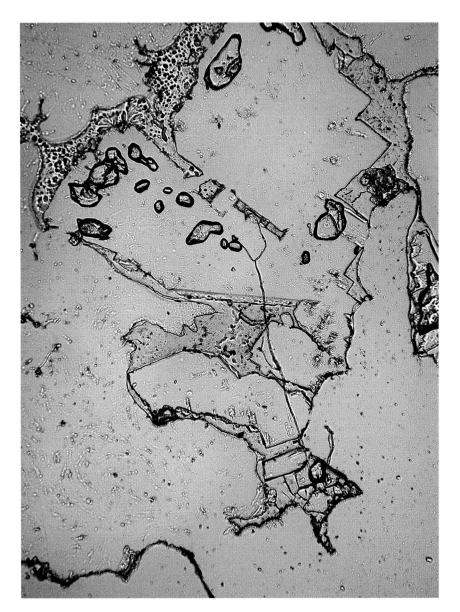

Now pivotal

Old mistakes under a new sky

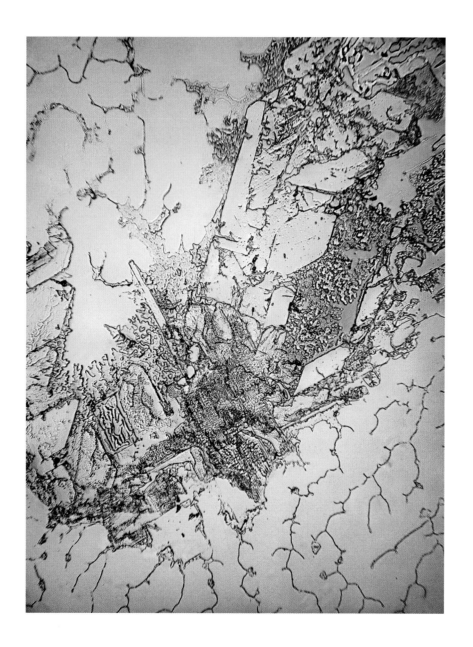

When forward is retreat

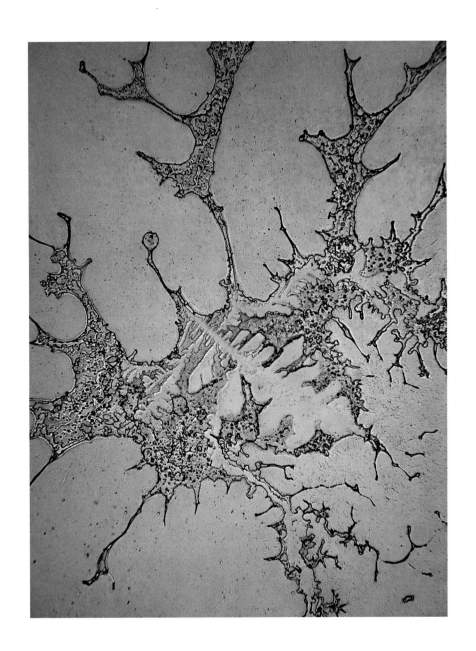

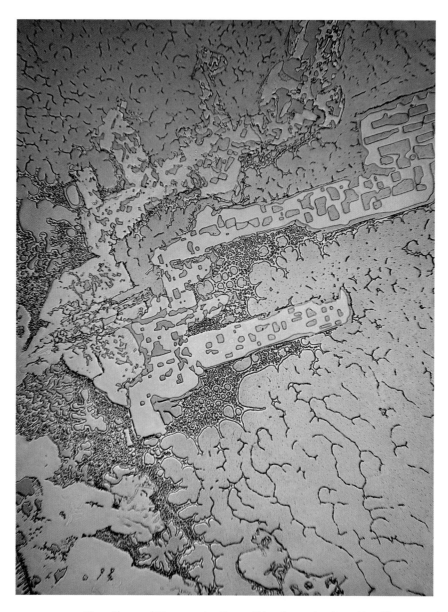

Near the end Tom wrote, Everything is poetry in action if you can love enough

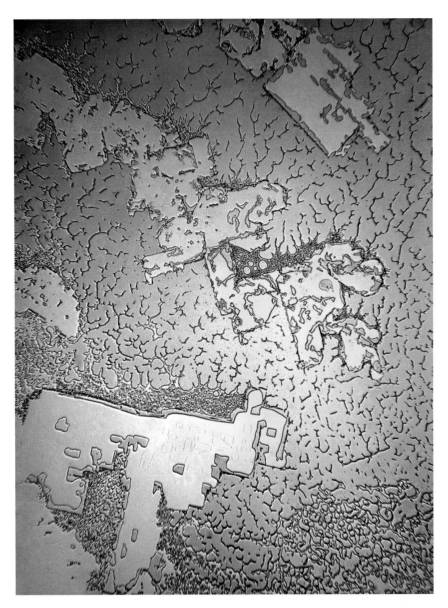

I remember you

Broken children

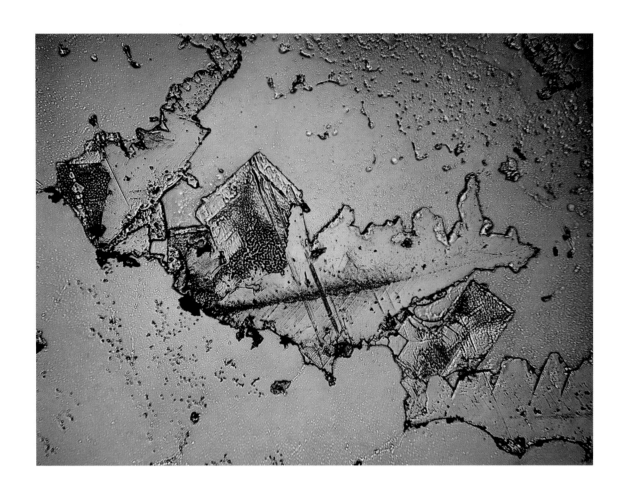

Tears for those who yearn for liberation

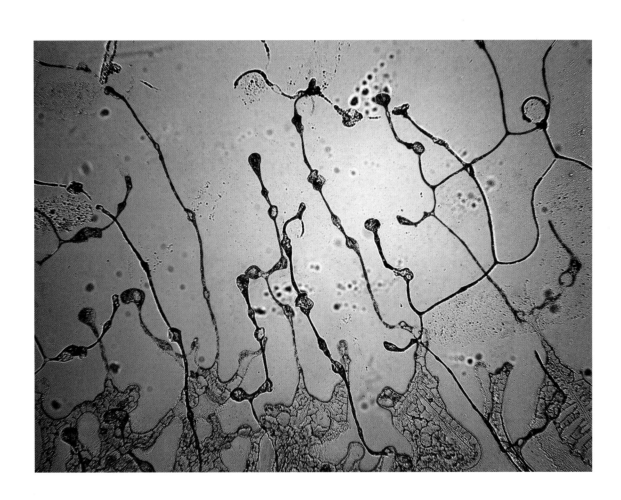

Its presence lingered a while, then it was gone

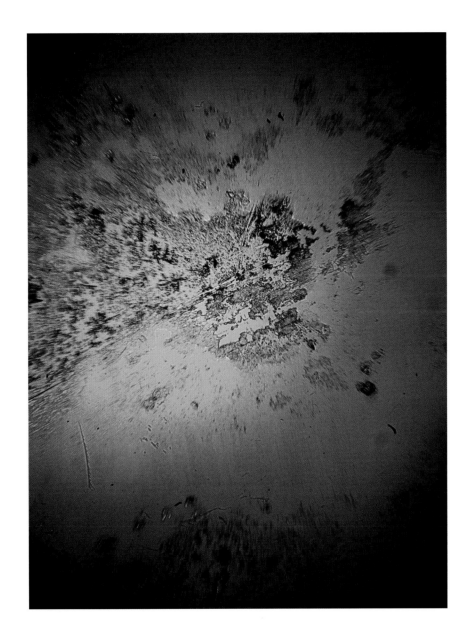

What it meant long after a time forgotten

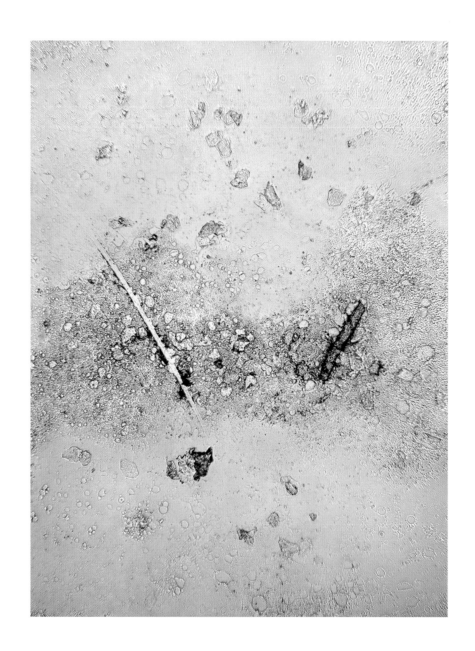

A generosity of belief

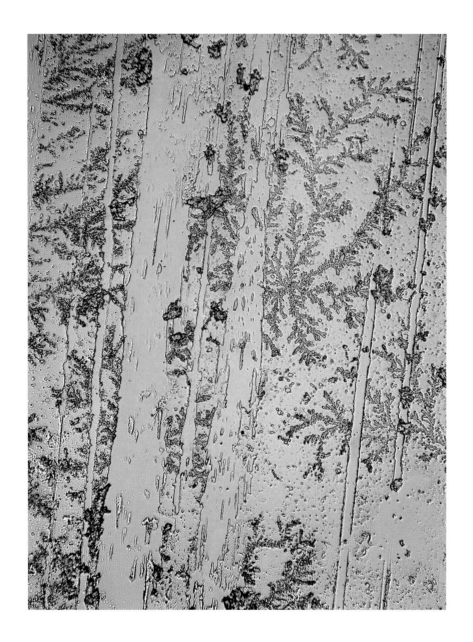

After the sun came the tears

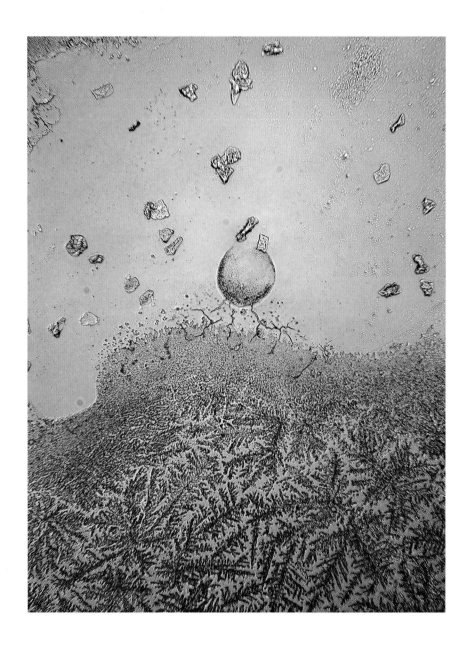

In the end it didn't matter (in 5 parts)

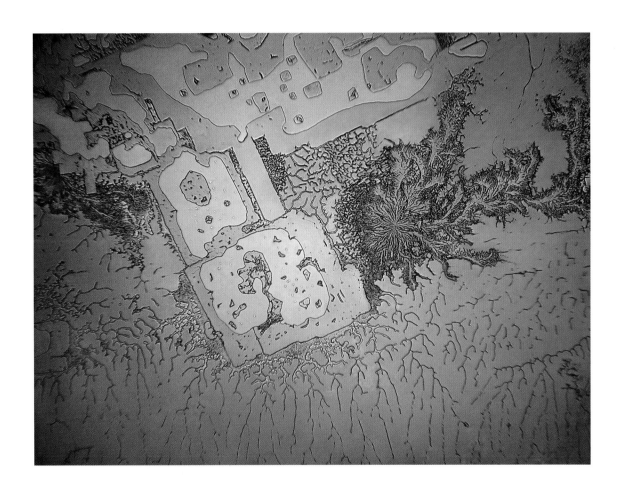

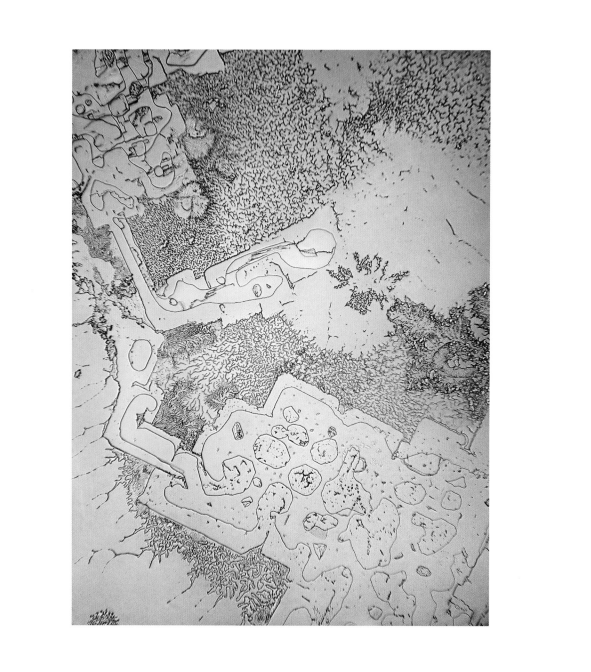

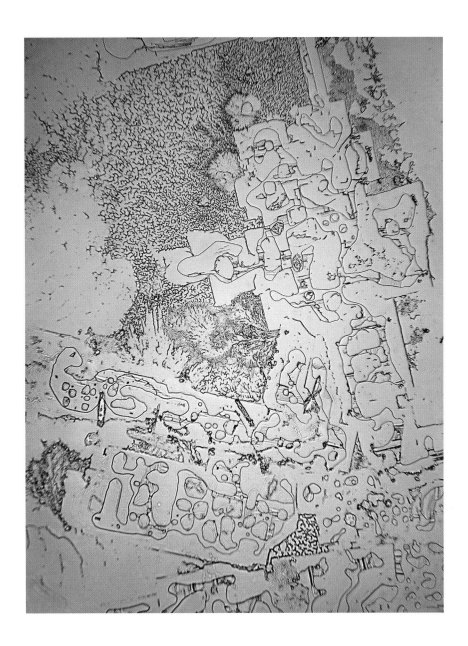

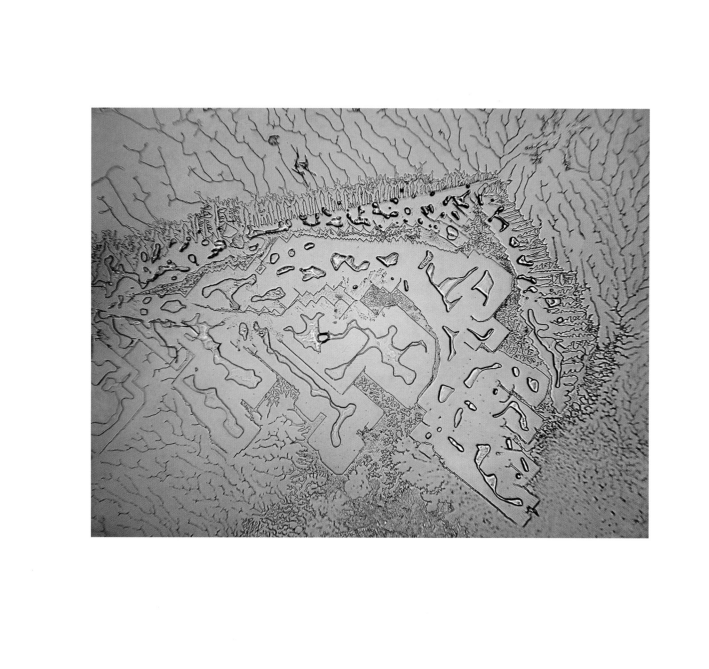

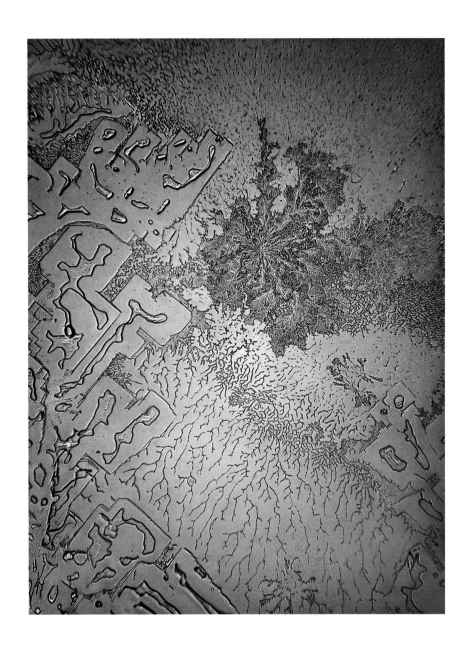

The opening day

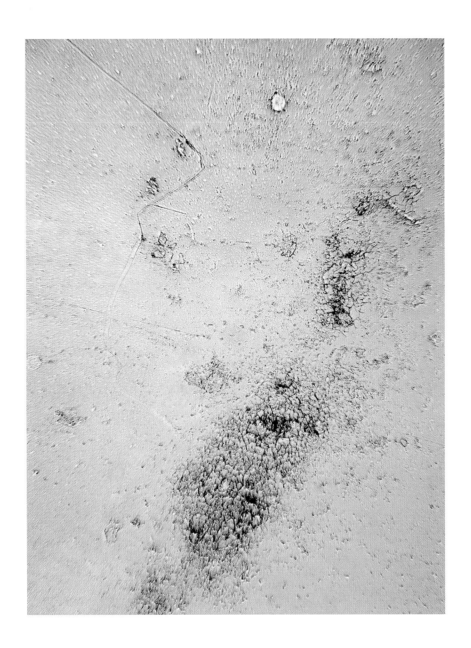

The breath between laughing and lace

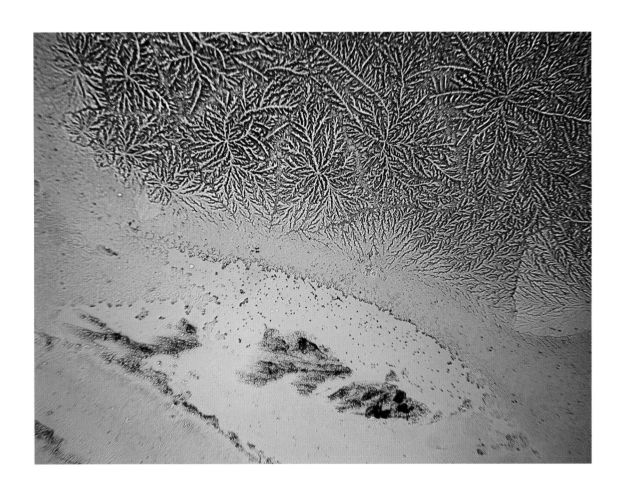

Overwhelmed #3

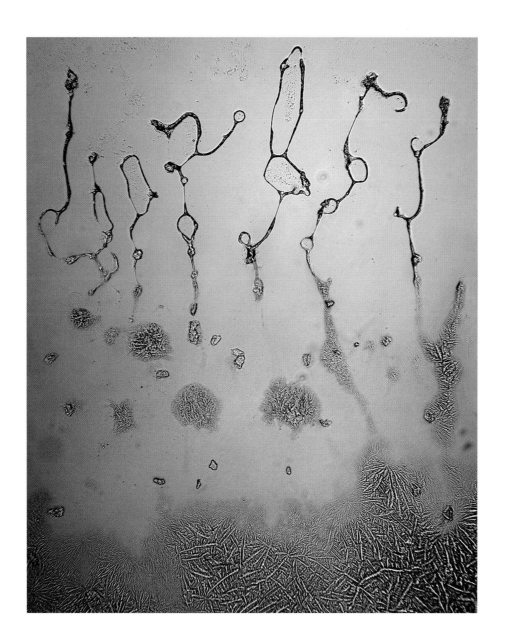

Nervous exhaustion

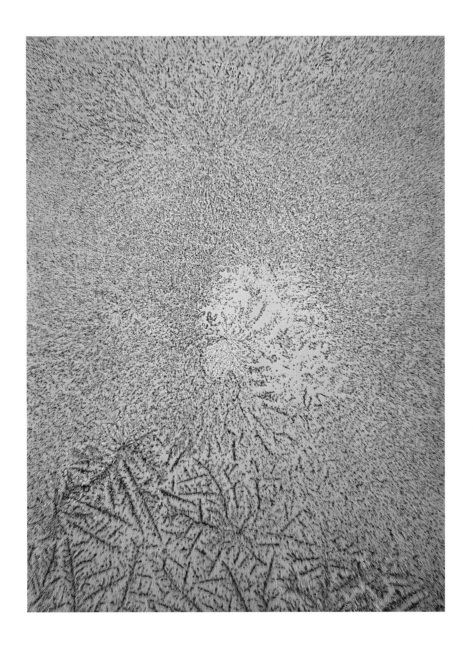

In commemoration, Charlotte Salomon

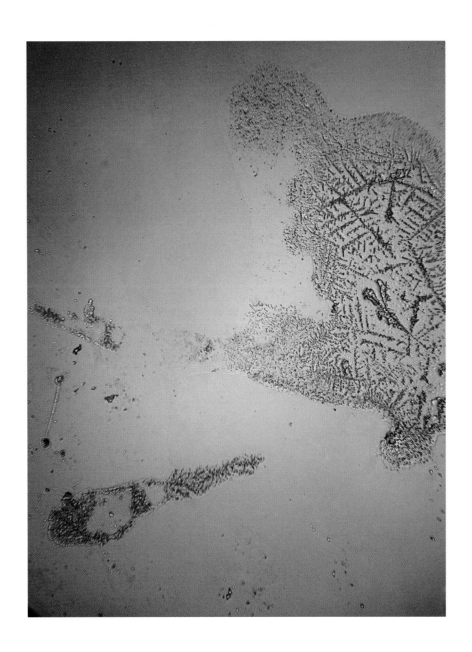

Redemption

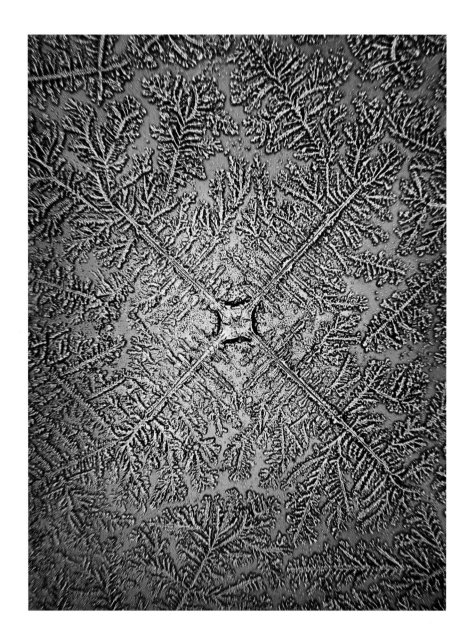

Body tears

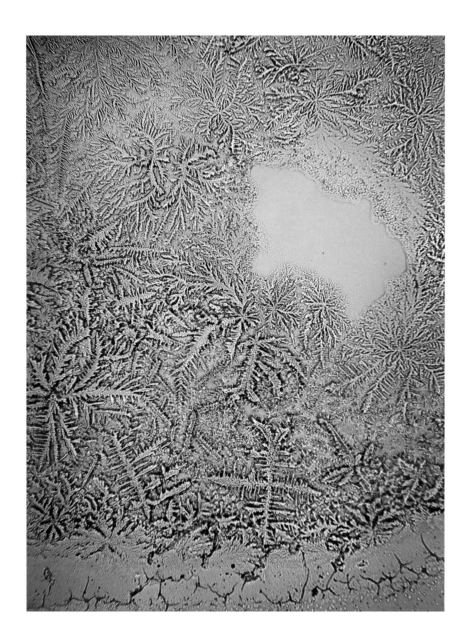

After goodbye

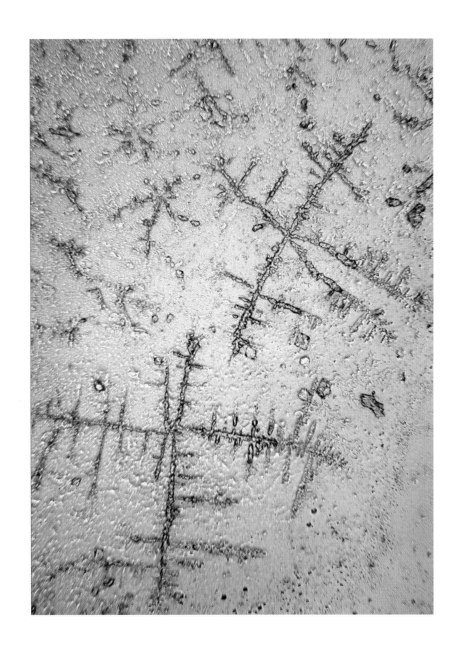

Takeoff

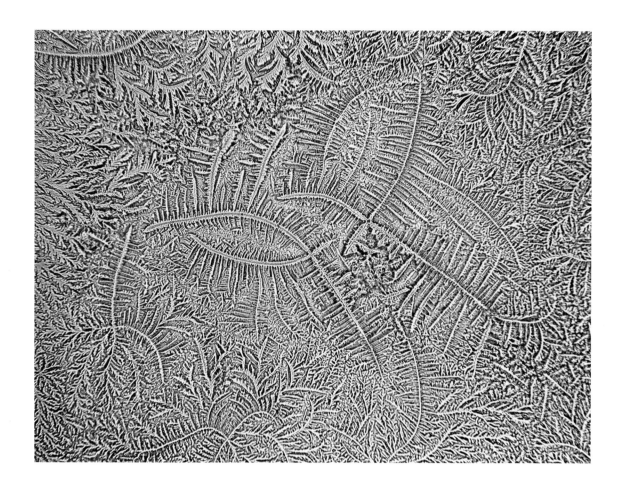

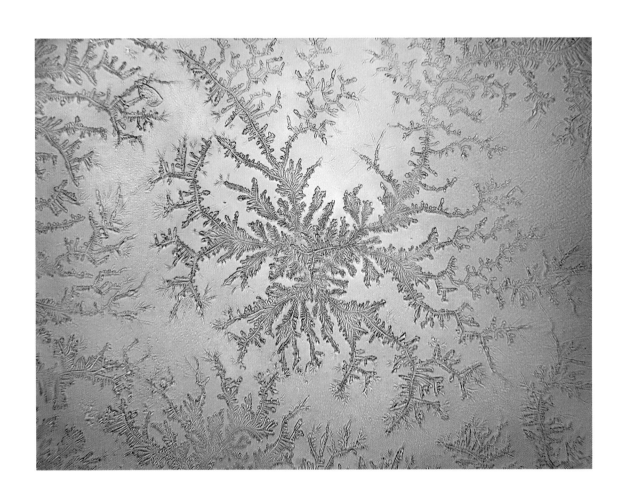

Last tear I ever cry for you

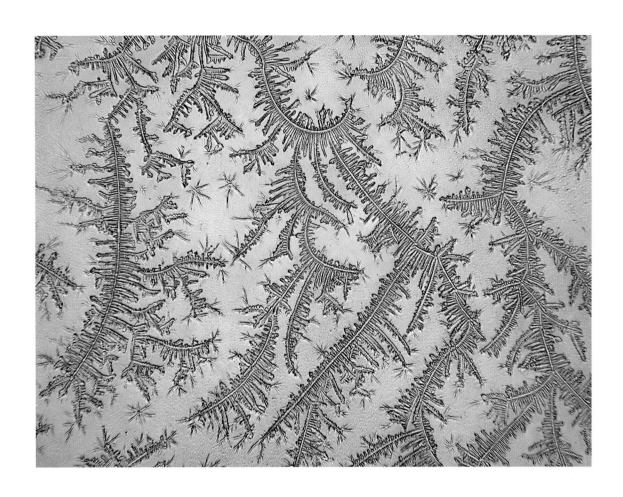

Tears and lace

Abounding, abiding

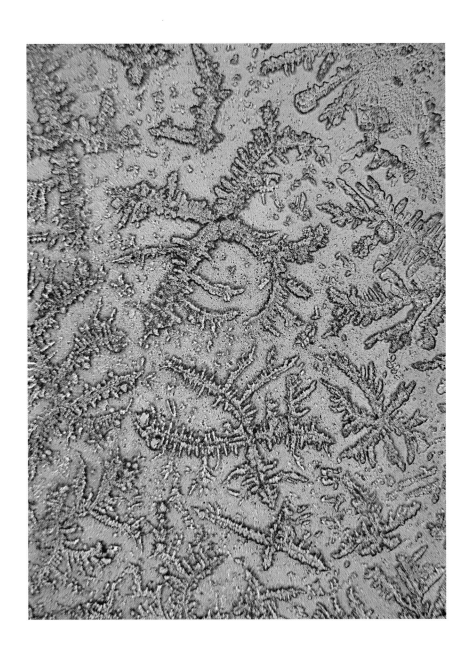

Saturated and depleted

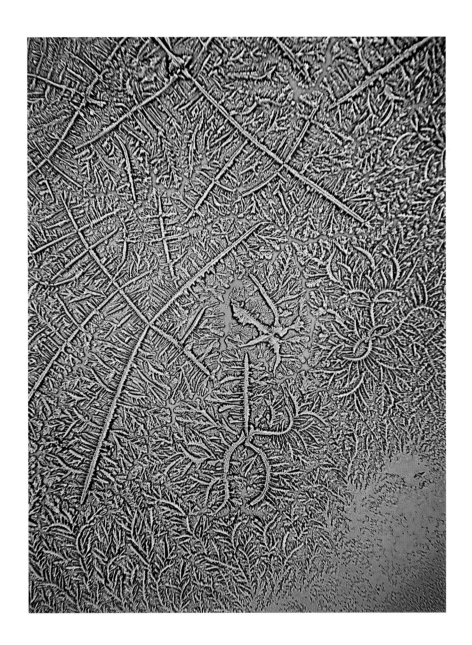

Your blessing lands inside me

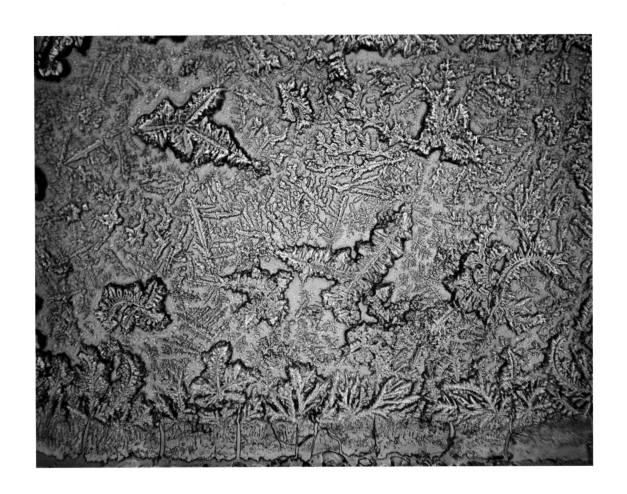

Godspeed, sweet light of my heart

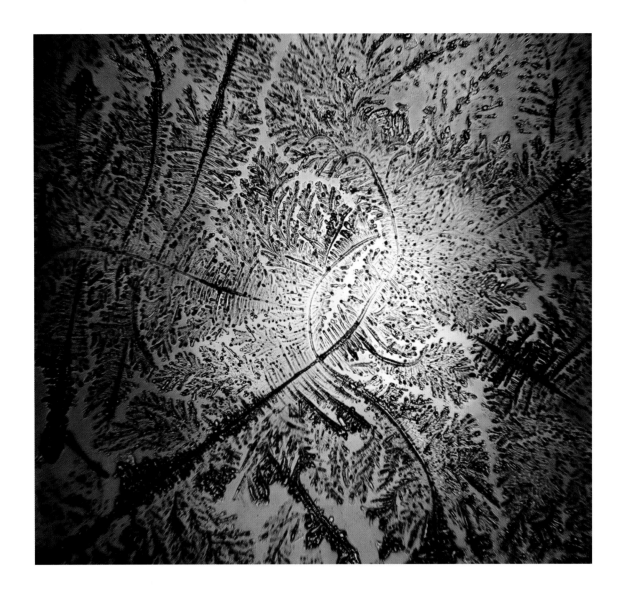

The boundaries of useless limitation

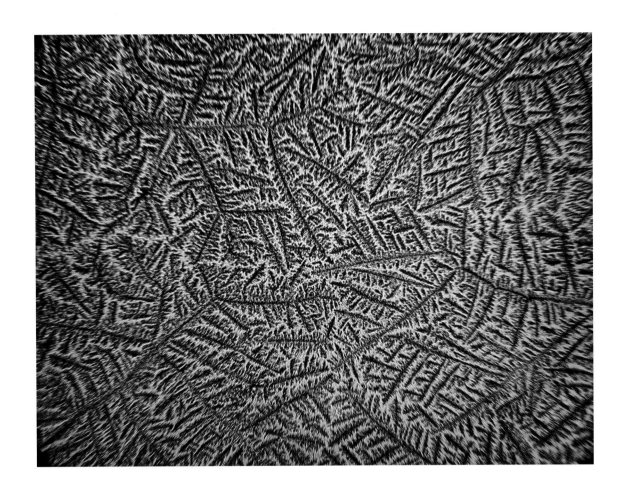

Compassion

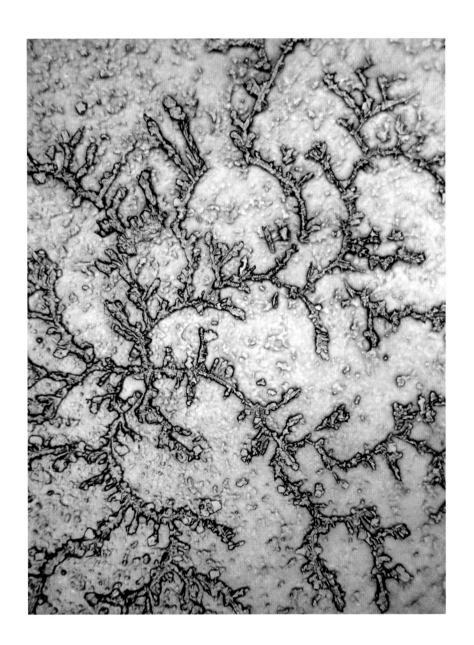

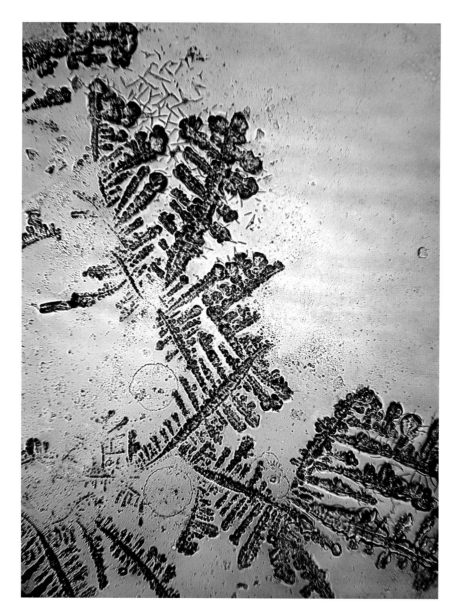

Yawning tears

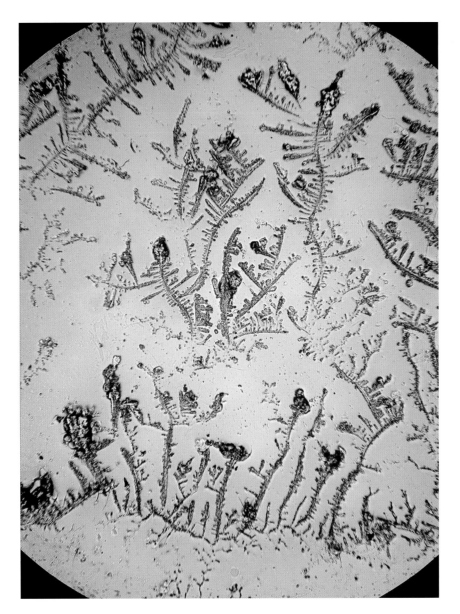

Baby tears

My brother's tears on the other side of a promise kept

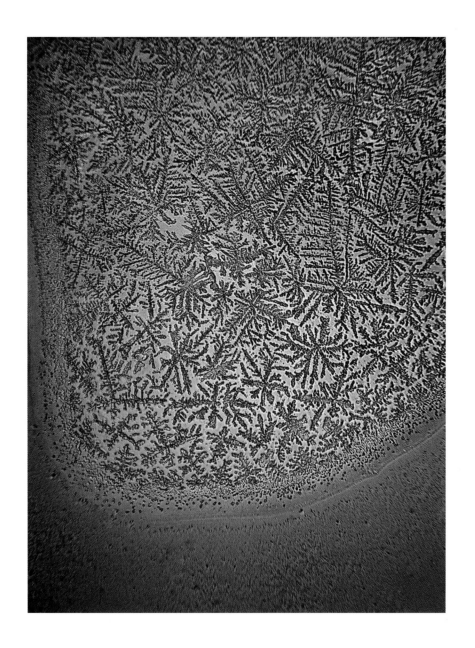

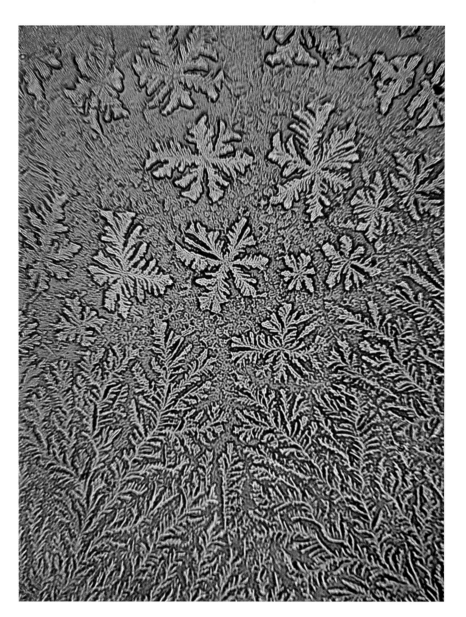

Quiet ripening

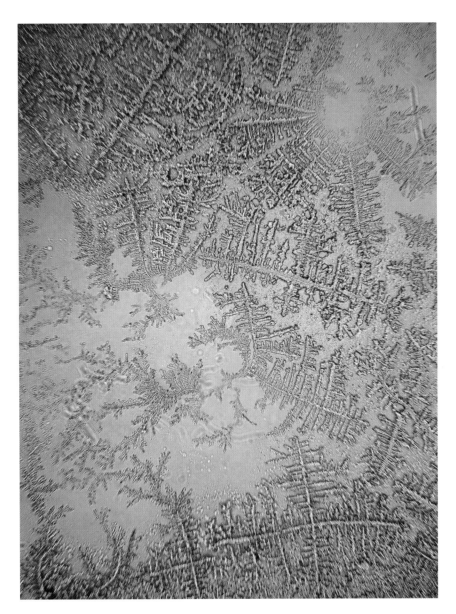

Concession

Onion tears (in 3 parts)

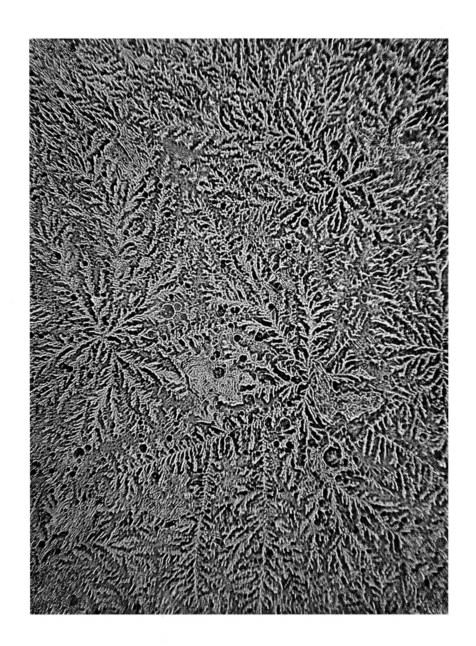

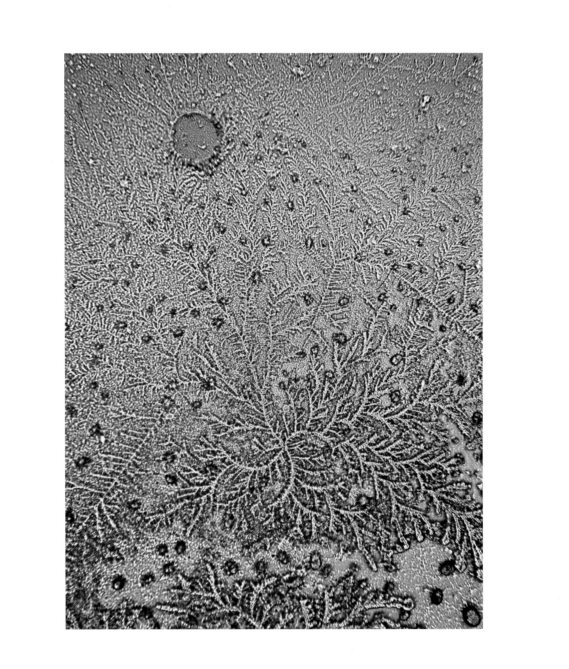

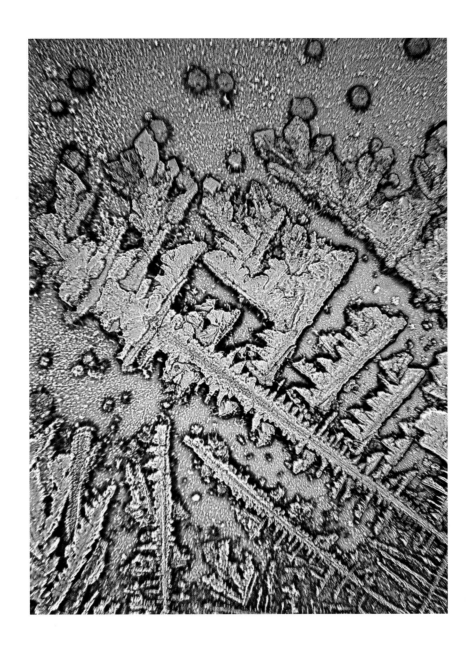

INSPIRATION BEHIND THE PROJECT

Rose-Lynn Fisher

An old envelope was lying on the floor in the hallway of my apartment. I didn't know how it got there but when I saw who it was from, I read the letter with a rush of memory and regret; twelve years had passed without any further contact.

The story began in 1979; I was young, fresh out of art school, traveling alone, and had just arrived in Florence on the night train from Paris. A pain in my hip had begun a few days earlier, but I refused to let that impede my pilgrimage to Italy. By the time I got off the train though, I could hardly walk.

I had a phone number of the friend of a friend, who, as I was told, had training as a healer, so I called and asked him about having a healing session, to which he laughed a little and said, actually I'm just a painter, but if you'd like to come by I can make you an omelet and try some massage.

A taxi dropped me off on Via dei Bentaccordi, a cobblestoned street so narrow that standing there for a brief moment I felt embraced by both sides of the road. But as I inched my way up the steps to the apartment, the thrill of being here in Florence was completely absorbed by the darkening realization that I was seriously in trouble. When the door opened I was greeted by the towering, white bearded, smiling-eyed British artist named Patrick, who welcomed me in like an old friend, prepared a meal, did his best to heal me, then declared that we must go immediately to Santa Croce.

With his arm functioning like a crane, he hoisted me across the piazza into the splendid

basilica to show me Giotto's frescoes and Michelangelo's tomb, so that I could have at least a taste of the treasures I longed to see; it was a triumph of inspiration over escalating fear.

Patrick insisted that I stay on until we could figure out a plan for medical care. That night he tied a string from his big toe to my bedpost across the entire apartment and said just tug if you need anything. Sometime before dawn, I did. I tugged the string and he showed up with a pot of tea and a book of cheerful stories that he read aloud until light appeared outside.

I got worse though, and paramedics were called to take me to the hospital; they were the Misericordia, hooded men who looked as if they came straight out of the time of the Plague, only more jovial. I wound up staying in the hospital for ten days. As it turned out, I was having an acute flare-up of a genetic condition, Gaucher disease, and the unbearable pain was due to a bone infarction occurring in my hip. Patrick and his young son visited at the beginning and end of each day. When I was well enough to travel home, he rode with me to the airport in Rome, several hours away, in an ambulance he recruited.

The intense, extraordinary cohesion of agony and adventure, desperation and laughter, marked this experience as one of the 'worst of times best of times' that forged our friendship. Letters and visits were ongoing until inexplicably, we gradually lost touch and our paths of contact atrophied.

Over the years, Patrick had come to symbolize for me the embodiment of kindness and generosity; a mind and heart able to generate delight and penetrate the deeper meaning in the midst of crisis while working out the solution. He had probably saved my life, me a virtual stranger, he my angel. But for all that, I had lost track of the person who was my friend. I was suddenly ashamed. This old letter from him was an imperative to find him again, to thank him again, to make sure he knew that he was one of the ones who had made my life more whole, more meaningful, more possible. He was probably in his eighties by now. What if I had missed my chance?

Internet searches, phone calls abroad, an email to someone who might know him. The very next day an email back, the subject heading: "Very much alive in Salisbury!" Moments later we were on the phone.

I went to visit in the spring, our reunion profound, perfect. My friend, glorious as a blend of ancient stone and the first buds of spring just before they burst open. Eighteen years had passed since we had last seen each other, but all was in place; implicit continuity.

It was fortunate timing. Difficult times lay ahead, on both sides. I lost beloved relatives and friends and my dog to sudden or terrible death. On a personal level I felt derailed and deeply frustrated. It was time to overhaul my life and I didn't know where to begin.

One day I received a call from Patrick's son to tell me he had just died. My tears were relentless. I cried for losing him, but even more for having found him again.

I suddenly wondered, what do all these tears actually look like? Are my tears of grief the same as my tears of gratitude? With another wave of tears, I saved some onto glass slides and went peering into my microscope. What I saw captivated me, inspired me, and launched this project. These were the tears of timeless reunion.

ACKNOWLEDGMENTS

With deepest gratitude to Bellevue Literary Press and the multitalented team who brought this book to fruition with shared vision and great care, I thank my publisher Erika Goldman, along with Crystal Sikma, Joe Gannon, Molly Mikolowski, Marjorie DeWitt, and Lawrence Wolfson. I'm especially grateful to my literary agent Amanda O'Connor at Trident Media Group for embracing the essence of this project and being so steadfast in finding its rightful home. I am indebted to biochemist William Frey II for his remarkable research, expertise, and insights on tears, and to poet Ann Lauterbach for her inspired words.

With loving appreciation I thank my family, friends, and colleagues for their presence, thoughts, and some of their tears; and remember my friend Stephen Harris who introduced me to the microrealm and taught me how to navigate within it.

I am grateful to Center/Review Santa Fe, and my reviewers, where a larger context for this project became possible and was set into motion.

My project would never have happened without the means to follow a spark of curiosity that led me beyond my own tears one sad day. My vintage Zeiss optical microscope and QImaging MP-5 digital camera had belonged to my cousin, Alan Harnish, a former cardiologist pursuing his theories on the human heart, a work he had begun after retirement and stayed passionate about. I am ever thankful to Laura and David Harnish for passing their father's research tools on to me. When I am at this microscope viewing and photographing tears, I think of Alan. I often imagine his encouraging smile for me, echoed by Dora his wife, both beloved and greatly missed.

Lastly I thank all of you who have shared your private stories and thoughts on tears via personal notes and blogs. You affirm that our deepest responses to life connect us to one another, to all of humanity.